Praise for St

The Feminine Light

"It's a lovely book. For women around the world, the questions raised in *The Feminine Light* are profound ones. The Tao, this universal and intimate balance, is at the heart and soul of our work through NoVo. Thank you for sharing!"

> - Jennifer Buffett, Board of Directors The Novo Foundation, www.NovoFoundation.org

"The realizations within *The Feminine Light* capture the heart of the "Great Mother's" teachings with love and directness. An experiential and useful exploration of *The Tao Te Ching* from the perspective of the feminine, or Yin, which speaks to the woman who is ever becoming and about the natural differences between being a woman and a man."

> - "LB" Terrence Brotherton, Practitioner and Teacher of Eastern Healing and Meditation, Disciple of Taoist Elixer Style, Los Angeles, CA.

"Through *The Feminine Light* we experience an amazing passage that provides profound insight into our feminine power and wisdom."

> - Dori DeCarlo, Talk Show Host of The Word of Mom Show and Founder/CEO S1 Safety First, www.s1bags.com

"Through the author's exploration of the trials and tribulations we all experience on our life's journey, we, as women, learn that we are continuously evolving, capable of immeasurable love and generosity as well as influence. Bravo!"

> - Cathy Malatesta, President of Lawless Entertainment, Inc; www.Lawlessent.com

"A quest toward self-discovery…"

> - Carol DeGoff, MS, Life and Pampering Coach for Women, www.Winning-Spirit.biz

The Feminine Light
The Tao Te Ching for Inspiring Women

The Power of Being

Stephany Lane Yarbrough, Ph.D.

Yarrow
Leaf
Publishing

The Feminine Light: The Tao Te Ching for Inspiring Women

First Edition

Published by Yarrow Leaf Publishing
P.O. Box 5188, Beverly Hills, CA 90209
Visit our website at www.YarrowLeaf.com
Contact@YarrowLeaf.com

Contributors and Editors: Kerri McManus, All Ivy Editing Services
Formatting: Pedernales Publishing
Cover Design: Kimberly Martin
Cover Photo: © iStockphoto.com / Anna Rassadnikova
Stephany Lane Yarbrough Photograph: © Philippe Paquet 2010

The author is grateful for permission to use the following previously copyrighted material: Jeaneane D. Fowler, *An Introduction to the Philosophy and Religion of Taoism: Pathways to Immortality* (Sussex Academic Press, 2005, www.sussex-academic.com); Hope Bradford, *Oracle of Compassion: The Living Word of Kuan Yin* (Booksurge, 2010), 18; Hsi Lai, *The Sexual Teachings of the White Tigress* (Destiny Books, 2001, www.Inner Traditions.com), 25.

Library of Congress Cataloging-in-Publication Data is available upon request.

ISBN 978-0-9831600-0-7

Dedication

*To the women who have the courage to love
with the wisdom and power of their souls...*

May your lives be blessed.

To Penny,
A magical woman
of clarity & candor
Thank you for
your soul!
Love & light,
Stephany
4-15-14

Contents

She Understands...

Acknowledgements

Lao-Tzu, thank you for your benevolence.

I send a thank you to my mother who many years ago gave me the first 1992 HarperPerennial pocket edition of Stephen Mitchell's version of *The Tao Te Ching* to reflect upon. May she rest with the Tao in Peace.

With my deepest love and gratitude to Kerri McManus for her dedication, time and editing support without which this work would have not come to fruition, to Terrence "LB" Brotherton for his formidable insights, to Philippe Paquet for his inspiration, support and photography as well as for his clarification of publishing opportunities, and to Dori DeCarlo, David Adams, Eon Garratt, Michelle Lidor, Aleya Sher Coolidge and Glenn Sean Yarbrough for their encouragement and comments. I would like to also thank Kevin Anderson, Roy Sonboleh, Dee Dee DeCorte, and Kimberly Martin for their thoughtful contributions. And finally, a very profound thank you to Jose Ramirez for his professionalism and care in the formatting of *The Feminine Light*.

Prologue

"...When you learn to take what is unseen (yin) and infuse it with what is seen (yang), then you control the workings of Heaven and Earth." -Hsi Lai

I send this book out to the world of women with the feeling that there is always more to discover, like that of a painter, such as perhaps Frida Kahlo or Georgia O'Keeffe, who, when finishing a canvas, wonders if the expression is fully completed. For me, the culmination of this writing is perhaps the beginning of a journey and with that in mind, I give this translated version of *The Tao Te Ching* to you. Through an understanding of the Tao, may we explore, create and share our journey together toward *The Feminine Light*.

The Tao (pronounced Dao) loosely translated into English from Chinese means the "way, path or truth," an all-embracing truth present everywhere. It is the Source of Life and the laws of nature, the polarities of existence, darkness and light. The Tao is the origin of the universe, a universe that can be discovered and experienced. The Tao is eternal and our souls, in "being" and in action, reflect its truth.

I would like to think we share a common starting point – an awareness of the Oneness of the Tao, the Source and Unity of life, and an understanding of our essential nature as women: the conduit for the Source of life in darkness and in light, no matter its name. And it is from this seed that we will, as women, begin to realize our darkness into light. To be able to recognize and honor with integrity our unique identities and return to the Tao as the Source for our own replenishment is the key to our innocence – the fountain of youth. While the path of innocence guides us toward our light, the awareness that darkness is the foundation of who we are provides us with a deep understanding of the Tao. And by *simply* humbling ourselves to the guidance of the Tao, we are then able to see ourselves more clearly, move with an enhanced fluidly through life, have a greater sense of fulfillment and expand our own enlightenment.

Simplicity does as simplicity is.

Simplicity

The best practitioners of Tao
In olden times
Did not use the Tao to awaken
People to knowledge,
But used it to restore
People to simplicity.

When people think they know the answers
They are difficult to guide.
When people do not know,
They can find their own way.
To govern,
The simplest pattern
Is the clearest.

To know these two principles
The Wise rule and measure
And keep always in mind
The standard of Subtle Insight.

Deep and far-reaching,
Subtle Insight
Returns all things
To peace and harmony.

And so, with and for a humility of consciousness, mindful of this verse, I gently write a new beginning.

The Feminine Light

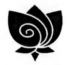

"All the people will not experience the love energy in the same way. Some will be comforted. Some will be changed. And some will be confused and even angry." -Kuan Yin

The complement of feminine light is darkness. Darkness is the unknown, the void; emptiness. Darkness has both negative and positive sides. A few of the negative symptoms of the void, whether found in individuals or cultures, are:

- Fears and phobias
- Workaholic debilitations
- Addictions
- The lack of freedom to learn, to speak, or to take action
- Depression, anger, and other emotional tensions
- Weight gain and other health concerns
- Conscious lack of integrity
- Celibacy plagued by guilt, shame, or disrespect
- Exhaustion
- Boredom and confusion
- Impatience with the tempo of personal transformation
- Distaste for the work necessary to discover the light
- Victimization by self or others
- Physical, sexual, emotional and/or spiritual abuse

Any time we are "stuck" in a negative situation, depending on the energy force involved in that negative experience, by becoming an artist of one's soul, we are given the opportunity for growth and self-illumination. To do this, we must understand and be able to work with the medium of darkness. As women and healers of humanity, it is important to learn how to embrace the unknown in order to change it into light.

The beneficial side of darkness is made possible by the very essence of darkness. The unknown is the foundation for light. It is the fertile ground of any creation; it is the beginning; it is the seed of illumination and the passage of self-illumination. If we are able to take the leap, illumination is made possible by discovering and answering questions about who we are: physically, emotionally, spiritually, mentally and socially in ways that honor our true identity. For some, this process of identifying ourselves may be easy, while for others it might be quite difficult. Yet, the difficulty has in itself the potential for greater understanding and requires an even stronger commitment of the soul. Any transformation entails moving into the unknown and then bringing truth to light: the truth of the soul. Darkness can be seen

3

then as a gift in itself. This gift is given to each and every one of us so that we may transform it into our own light.

I wrote this book specifically for women. As I see it, the Tao begins with the feminine, as does all aspects of life. We are the forbearers of light and so I thought a new version of *The Tao Te Ching*, interpreted and written for women and by a woman to honor the feminine, was timely. Though several books about *The Tao Te Ching* have been interpreted by women, including works by Ellen M. Chen (her dissertation in 1966), Ursula K. Le Guin, and Kari Hohne, this particular version is presented solely to and for women. Taoism supports the notion that women are the spiritual leaders of humanity, as the divine is the feminine spirit. It is by the healing of ourselves as women, helping us to bring forth our wisdom guided by love, that light is made possible – *The Feminine Light*.[1]

For me, this publication is a culmination of the transformation of some of my darkness. My youthful past suggested to me that I needed to learn about and understand "boundaries, limitations and distinctions of energy" and how not to be a "victim" of my giving love. So I followed a path of my own making, often unconsciously, which included research in the field of Human Development through the life span where I focused my efforts as a theorist on boundaries. After the completion of my Doctoral degree, I focused specifically on researching women's development and identity as well as gender relations. Today, I feel I am giving now from a place of wisdom and love, moving into the expression of my joy and, more than ever before, being open to receiving new understandings of my life's passage.

My journey has been a long and unusual one, resting in and codifying from a phenomenological perspective the nature of the identity of women. In the course of swimming in these dark unchartered waters, I have been guided by a faith in the world of the "unseen." I have listened for meaning and meaning has been given and in doing so, I experienced a tremendous influx of creative insight.

During this time, I had to learn not only patience and humility

1 For more academic sources, I recommend the writings of Lao-Tzu, *Lao Zi: Dao De Jing* translated by Wenliang Tao, *The Tao-Te-Ching* by Livia Kohn and Michael LaFargue, *An Introduction to the Philosophy and Religion of Taoism* by Jeaneane D. Fowler and/or writings by Eva Wong.

(life not being measured by traditional values of success) but, while listening to my journey and the timing of its expression, I also had to stay true to my course. Like an artist who creates from the unknown, I was constantly experimenting and discovering, feeling I was giving birth to something new. My studies in Taoism have allowed me during this uncertain gestation period to ground myself. Today, *The Tao Te Ching* continues to provide me with a balance and a way to discern meaning from my experiences. I find that centering in my own spirit is a practical guide in the unveiling of light.

I have spent more than twenty years as a student of *The Tao Te Ching*. Although my background is in Psychology, I incorporated Taoism into the foundational basis for my graduate work with the concept of Boundaries: Identity Formation, Maintenance and Management. Since then, as a life-span developmental research psychologist focusing on women's identity and empowerment, I have continued my practice in Taoism.

In the last five years, I have been immersed on a daily basis in Stephen Mitchell's First HarperPerennial edition *Tao Te Ching* (1992) as a divining tool for the energy of each day, learning even more about the nuances and subtleties of the Tao. I have attended quietly and reflected upon my experience and in doing so, have attempted to understand its spiritual language. Learning a language is quite difficult for me. It requires a new thought process, a change of consciousness, diving into and immersing oneself into the artistry of language. The language of the Tao is clean, pure, without artifice. It is a language that speaks to essence and to the very foundations of life, that which makes up union, wholeness and health. That foundation is built upon the manifestation of Yin and Yang, the feminine and the masculine. Nothing has any reality, meaning, or value outside of its relation to the Tao and its dynamic polarities, the principles of Yin and Yang.

Yin and Yang describe attributes of feminine and masculine energies – opposite, yet complimentary forces of the Universe. In *An Introduction to the Philosophy and Religion of Taoism*, Jeaneane D. Fowler writes, "The continuous transformation and rhythmic patterns of Yin and Yang, their waxing and waning, coming and going, rising and falling, are related to all phenomena in the universe... The degree of balance and tension created account for all things. Thus, Yin and Yang are the qualitative essences found in all entities of the universe,

constantly reacting with each other." While Yin is passive – it receives, is soft and dark, and is represented by the moon, the direction of north, the color black and even numbers, Yang is active – it gives, is hard and bright, and is represented by the sun, the direction of south, the color red, and odd numbers. This distinction or polarity is also found between woman and man, though as humans we are a mixture of both polarities.[2]

For the purpose of clarity, let us examine the distinct concepts of womanhood and manhood. These concepts can be understood by investigating the term *spirit*:

"Spirit," from Latin *spiritus*, literally means the breath, to breathe or to blow. It is the vital principle which gives life to physical organisms. It is the animating essence, force, or energy as distinct from matter. The word spirit also refers to the soul or the intelligent, immaterial and immortal part of a person.

In defining the word spirit, the distinction between womanhood and manhood can be made: women *are* spirit (the egg), that of being, and men *have* spirit (the sperm), that of doing. While life consists of both "being" and "doing" as well as their interconnection, life is born from the unity of that which is spirit – known as the Mother or the giver of life. This fundamental distinction between women and men is a profound one and our starting point.

Some principles are like that: just as in the very essence of *The Tao Te Ching*, one senses that they are true. Some people may prefer to argue that manhood is spirit as seen by all the men who hold spiritual positions in societies, however, while men are human beings, intelligent and have souls, they are only extensions of spirit and can, in various degrees, have greater or lesser access to the spirit. They *have* spirit to go forth, to do, to act, or to be, **but they are not spirit**. This does not reduce the worth of men, but simply respects men's qualities and the qualities of manhood as distinct and separate from that of women. Women *are* spirit, as well as human beings who have souls. This is the reason why it is so important that women not only

2 This is applied to those whose gender identities are in alignment with their physical bodies. For some others, as in homosexuals, lesbians, trans-gender people, etc., their journeys are much more complex in the qualitative application of the feminine and masculine energies of Yin and Yang.

respect themselves but also are respected. *Women are the spirit of the world.*

Why is it that women's development has more to do with nurturing and caring for someone or something? The woman is spirit and therefore provides the spiritual nutrients to the world. Through her spirit, she is the direct connector between the Tao and human beings. By entrusting and uplifting her spirit and by representing the Tao with integrity, she empowers the world around her.

This distinction made between women and men offers an explanation regarding the hostility found in some men toward women, discrediting them, blaming them, enslaving them and usurping the identity that belongs to them.

I cry... and my soul fills up with sadness. This observation is in no way a slight against men. I very much appreciate and respect honorable men. Yet, we all have our own lessons in this developmental journey called "life." When the hard lessons have been learned and when darkness has been turned into enough light to live in peace, we will all eventually open our hearts in love.

Personal Contentment

The highest good is like water,
Nourishing and benefiting without trying.
It flows in low places that others disdain.
And thus, like the Tao,
The Wise remember:

In dwelling, keep close to the ground.
In thinking, embrace what is profound.
In conflict, be fair and love humanity.
In communicating, hold to the truth.
In governing, honor order and peace.
In working, be competent and enjoy.
In action, be timely.

When one is content with oneself,
Without comparison or competition,
There is no blame.

Such an observation, however, regarding the hostility toward women, is only a recognition that approximately three quarters of the world's male population subjugate women through sexual abuse, slavery, physical threats and harm, genital mutilation, thievery, spiritual devaluing, emotional scorn, forced labor and death. This mistreatment is, and has historically been, widespread.[3]

There are many cultures and therefore a multitude of gray areas in the context of gender development. In some cultures, women are still thought of as chattel. I respect how cultures evolve and have compassion for all who are struggling to find themselves and be happy with their lives. It is not an easy task to sort out life, given the complexity of information, as well as the dynamics of personal emotions; yet, still, gray is a shade of darkness. Darkness, the unknown, often overwhelms people out of fear. Now, as we are living more and more in a global community, the unknown takes on even greater proportions and the symptoms of the void are recognized as widespread.

All women have different quests, ways to differentiate themselves. My passage relates to learning about the nature of womanhood and then creating an overview of the life, purpose, and self-ownership of womanhood. This path of mine to codify and focus awareness on the very nature of "being" as a woman, what it means, its purpose and value – taken as a natural state by some women – may seem unnecessary. Not to me. For some men, a woman's light may appear threatening due to its unknown nature, their inability to share power, their own issues of self-esteem or their fear of potential abuse by women.

Men are at the mercy of women in a different way than women are at the mercy of men. Men are emotionally and sexually at the mercy of women and women are emotionally and physically at the mercy of men. Extending love comes from the love that is within, both for a woman and a man. I am not a "feminist" in terms of disregarding men, but I am in terms of regarding women first as human beings. I am concerned with the valuation of women as women, not in terms of using the masculine model of development and valuation

3 For more global information on women, see the websites:
www.unifem.org and www.feminist.com/antiviolence/facts.html

as a measure for women, but in creating our own developmental model. I believe women are coming into their own in order to evolve and empower themselves as women, to rightly claim and reinstate their spiritual worth as women and take their place in harmonious partnership with men. Given the previously mentioned atrocities, it is no wonder women have felt the need to take up arms through any number of avenues to defend and protect their lives as well as to be able to exercise the full expression of their spirits. However, there is no need to fight for the dignity of life – there is a better way.

Subtlety

Ruling a large country
Is like cooking a small fish,
To be handled delicately.
If in accordance with the Tao,
Evil will lose its power.
Not that spirits will have no power,
But the powers will not be harmful,
As the Wise do not harm people.
Evil, given nothing to harm,
Disappears by itself.

The Tao is subtle. And the negative symptoms of emptiness can be understood, eased, and healed through the illumination of the Tao.

We all have experienced to some degree our own darkness and its negative symptoms, as detailed earlier. However, when we speak of truths, we speak from the heart – an opening toward the light through which realization and growth are made possible. What lessons or themes can be learned from the symptoms of emptiness? Which themes of the void have you experienced in your life? What hopes or dreams have you wanted to create for yourself, but have not yet been able to implement? These truths speak to the very essence of who you are. We all want in various degrees to love and be loved for who we are as human beings as well as for our sense of worth.

We women, in order to discover our identity and as well for our self-preservation, have needed to find a means of economic independence while we continue to gain our rights as human beings, and learn to experience our own self-love and joy. In doing so, however, we have reached a "tipping point" in our own evolution; in following a male model of development, some of us have unconsciously lost our own light and devalued our own worth as women. If our value as women has been recognized in our culture, we have seemingly turned away from it – by disowning it in varying degrees, or minimizing it in favor of "competing" with men in the work force. One result has been the devaluation of men and their bodies instead of an honored partnership. This has created a timely upheaval and confusion between the sexes.

Men are losing their sense of worth in their state of manhood, not only in the workforce, but also in honoring the feminine spirit. Men need to compete with each other and now with women too, or they have become lazy as women do the work. Men are often still predators of women's spirit, but this time they do it in the name of ignorance or under the guise of "equal treatment." Some women have lost their wisdom; some men have lost their respect for women and for themselves as men. When women ground themselves in their value as women and become leaders with their own light, they will no longer need to be "victims" of darkness or of men, but rather their spirits will be respected and cherished. For many of us, we can choose how we want our love to be respected and how we want to honor love. For many other women around the world, this is yet just a possibility.

Wherever you live, embrace your life, experience your truth, come to know yourself in the full expression of your heart's glory; trust your instincts, yet measure them by what you want. This is the beginning of self-accountability and the owning of your light. Without owning your own light, attraction is alluring and the heart can easily be fooled. Symptoms of the unknown seek drama and, though liberating in expression, drama is more like a girl who, without self-autonomy, has no other recourse other than making emotional demands to try to meet her needs. Maturity weighs both the heart and mind to ascertain the truth; moderation ripens the soul. Learning self-ownership and self-acceptance are processes that require exploration, diligence and commitment, even while supporting yourself in finding and manifesting your own self-love and joy.

Do you want to be self-accountable or a victim? What do you choose? And what do you honor in your receiving and giving?

As a woman, what is your dream? What is your profound sense of joy?

My upbringing was not traditionally feminine. Personally this, through time, has given me an understanding that my dream has always been, in many ways, to be appreciated and valued as a woman, to know what womanhood is, and to be safe and happy in my joy without needing to think. After the culmination of twenty years in a kind of self-imposed darkness researching the nature of womanhood and creating artistic expressions revealing the questions I have been asking as well my findings, I am now ready to show my work and to live more in a place of ease. Life, up until this point, has been a sometimes harrowing process of expansion, reduction, and its various oscillations. I have learned to find peace along the way of discovering, expressing, and manifesting my identity as a woman through self-accountability and self-ownership.

A heart that only speaks to itself is a heart not yet fulfilled.

And so many of us seem confused; we either don't know, or now, with the opportunity for increased independence, don't care that when knowledge of the feminine is lost, for whatever reason, chaos begins. When there is an over-valuation of the masculine, the feminine

suffers, and so too does the world. In the darkness there is light, and by wrestling with the darkness, we are able to find the light. The unknown is the beginning of all creation.

Today, while in many parts of the world women are still struggling to survive, I wonder, how many women in primarily Western cultures, understand or reflect on the past and what women have fought for – in terms of their liberties, as well as in honoring themselves as women. Is not our emptiness our own creation? Has it been easier to borrow the light of man than to create our own? Is it that we no longer feel the need to inquire about our own identity as women, aside from questions of equality with men in terms of confidence, opportunities and financial worth? What are we creating? What is the value of a woman? Where is her confidence being placed? Where has the woman gone? With a proper foundation, we can find ourselves. Listen inward and find the roots.

Ambition

When the Way is lost,
The doctrine of humanity arises.
When the doctrine of humanity is lost,
Justice arises.
When justice is lost,
Righteousness appears.
When righteousness is lost,
There is ritual.
And without knowledge of the Tao,
Only the edge of loyalty and trust remains,
The onset of confusion and Chaos.

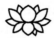

–Taken from the verse titled *Ambition*

At the beginning of Chaos is the void, and in this emptiness is where we find *the feminine light*.

The world starts with you as a woman. The light that we, as women, individually nurture and express, becomes the potential collective light of all women.[4]

The world begins with a woman's body and the self-respect she has for her body. She is a conduit of the Source. A man knows this, and so what is joy for a man but his contact with the Source. Though there are different ways of connecting with the Source for a man in relation to a woman, the most intimate contact a man can experience is through sexuality. So, for a man to postpone sex or joy until he has given to her in such a way as to please or satisfy the value of her spirit – to love her – is to know that his offer has been accepted and that he is validated by her love. Choose wisely and love consciously. A woman's acceptance of man is her domain, her purpose, and her choice. It is her body, her connection with the Source that connects him.

4 To further explore the nature of womanhood, our developmental passages, purpose, worth, identity and empowerment, go to www.DaVincisMuse.com. Let our voices be heard.

Love

The Tao never dies.
It is the Great Mother,
Which gives birth to infinite worlds.

Forever and inexhaustibly present within you,
Effortlessly, it can be put into practice for any use.

The woman's voice is her power; her subtlety is her strength; her patience is her knowing; her anger is her sadness; her beauty is her clarity; her light is her radiance; her truth is her inviolate reception of and connection with the Source, the all-encompassing unity and consciousness of life; the lifeline of humanity and the giver of love.

A woman's light and the resulting profound expression of its value, her love and her joy, is the holy grail, the fountain of youth, the life force everlasting, no matter its expression – through birthing and raising children, listening to the muse in the creation of art, hearing a "calling," utilizing her intelligence, talents and abilities, traveling, creating a home, nourishing relationships, nurturing the body, supporting a cause, participating in any number of interests, or being in love. Whatever form her light takes, it is the manifestation of her truth and, as such, is a revelation of spirit and her connection with the Tao.

Understanding the distinctions between simply being a woman and consciously owning your value is the first step toward recovering from the negative symptoms of darkness and acknowledging your light, enabling your truth and love to nurture your world in ways that foster growth and wholeness. The world is of your choosing. What is your love and joy? In nurturing your world, what would you like to receive?

My love and joy is loving and being loved, cherished, valued by a man I respect, creating a life with him – this man who honors, respects and promotes my love and joy as I represent his spirit and give to him. I am an idealist, and this is true. The most difficult lessons I have needed to learn have had to do with receiving and the ways I have blocked my ability to receive. My desire to plan the future and accomplish a great deal, as well as extend my goodwill and assist others with their lives, all have been ways of blocking. My natural inclination is to be ambitious and to give, so for me, to live in the moment requires patience and a commitment to my unfolding. And when I want to make sure others are taken care of, clearing a path to honor myself, to receive from myself, sometimes takes concentrated effort. Receiving from others is appreciated when the giving comes from a place of integrity, and/or if I choose to be a willing receiver, though at times following the Tao has required me to let go of relationships. As I did, a different energy emerged: one that has allowed me to discover new

approaches to my unique voyage and has heightened my sense of possibility as well as my ability to receive. What I have received has come in the form of spiritual light.

The spirit endures and fortitude compels; even when the world mirrors the changes that we desire as yet unfulfilled, change is possible and the unfolding of life is manifested. I have experienced these changes intensely. These changes through time have shifted me from that of the conscious undifferentiated unified feminine energy to a separate masculine consciousness in order to make distinctions, to create an individual understanding and then to return to the feminine with *the feminine light* – the light that is womanhood and me as a woman.

Women today have the ability to change the world by balancing the powers of the masculine-physical world with that of the feminine-spiritual world. In taking responsibility for our own self-esteem, we can, though the use of darkness, embrace our creativity and light, and move toward a more empowered existence. As fulfilled women and mothers, not predisposed to the negative symptoms of darkness by the lack of an awakened feminine consciousness or by a masculine dominant, we can give birth to enlightened partnerships, a renewal of our own spirits and, eventually, a more peaceful Way.

This book represents the foundational practice that has supported the structure of all my years of work. I hope that in sharing the following verses, they will support and fulfill you in living more fully *your feminine light*.

Let us find and lift our voices out of our darkness together.

The Tao Te Ching - The Lotus Blossoms

"From caring comes courage." -Lao-Tzu

The Tao Te Ching is a simple yet deeply rich book containing 81 verses relating to the ways of nature. They speak to the truths of the universe in order to help you find your path and to live your life in harmony with yourself and others. *The Tao Te Ching* was written by Lao-Tzu, a Chinese philosopher who lived in the 6th century B.C., though there may have been additional collaborative authors.

I have researched more than twenty translations, of which I used thirteen, all written by men, to synthesize my work and to rewrite the language in order to offer this new version to women. In this book, you will not only find the translated verses, but also the titles I have created for each verse, both reflecting how to be in balance with The Tao. An understanding of this balance is key if we wish to claim the importance of our safety and happiness, as well as our empowerment – being accountable for our own lives. I have kept this book short, in line with the circumspect nature of its fundamental truth. Enjoy contemplating each verse. In doing so, breathe in its life and the meaning it has for you. This is a book of inspiration; so let the stanzas touch you. You may want to sit quietly and meditate upon each of the verses separately one after the other or possibly choose a verse for each day and let that verse guide you. The "Way" is specific to you and how you desire to honor your own inward reflection, so welcome the writings in the style that is best for you.

Since joy is an extension of and is based on a foundation of love and worth, I have added questions beneath each verse to assist you in reflecting on your emotions and values as a human being and, moreover, as a woman who respects and appreciates herself. Asking and answering questions, this learning process, prepares the way for self-ownership, accountability and self-compassion – fundamental truths that point the way toward your own light.

In reading *The Tao Te Ching*, may you experience the blossoming of your own lotus. Breathe, release the past of any suffering, forgive yourself and others, and embrace your love and joy and feminine light.

The Tao Te Ching

She Understands...

Secret of Life

The Tao that can be spoken
Is not the eternal Tao.
The name that can be named
Is not the enduring name.

That which has no name is
The eternal Truth,
Yet the act of naming is the origin
Of all particular things.

Freedom from longing,
One lives in the mystery.
Desiring creates
Expectations and manifestations.

Mystery and manifestations
Are born from the same Infinite Source
And this Source is known as Darkness.

Mystery upon Darkness reveals
The infinite potential of Darkness,
The gateway to understanding
The Secret of Life.

Can one name the Tao? Do you want to learn about the Divine Tao? Do you trust the Infinite Source? Does love guide you in finding yourself? Do you welcome the Darkness in you as a gateway to discovering the beauty of your light? Can you accept yourself as well as others when in Darkness? Are you a friend of humanity? Can you offer all of humankind compassion and tolerance? Do you want to embrace the Unknown of your life with love? Do you revere the potential of The Secret of Life?

Centering

Polarities exist, when beauty is seen
So too is created the concept of ugly.
When goodness or value arises,
So too is created the absence of good
And the lack of value.

Being and non-being are One.
Difficult and easy are complements.
Long and short are contrasts.
High and low are distinctions.
Before and after are sequences.

Therefore the Wise
Can act without doing
And teach without a sound.
Things arise and the Wise accept them.
Things disappear and the Wise make no claim.
Without possessing, the Wise possess,
Take action, but do not assert.
When the work is done, the Wise detach
And remain forever.

Are you or have you been a victim of joy? Of your joy, someone else's joy, or both? Has the expression of your love or joy been painful? Can you refrain from criticizing severely the worth of others? Can you forgive the self-esteem of another and love yourself? Can you acknowledge people while centering yourself? Can you release your connection with those you need to in order to maintain your truth?

Value

If one overvalues great people,
One is reduced in power.
If one over esteems possessions,
The concept of stealing emerges.

The Wise lead
By releasing thoughts in people's minds
And supplying their spirit,
By minimizing their ambition
And strengthening their resolve.
The Wise help people to lose
Everything they know,
All that they desire,
To create confusion
In those who only think they know.

Practice not doing
And all will fall into place.

What self-truth gives you resolve?

Resourcefulness

The Tao is like a Chalice
Of Infinite possibilities,
Used but never exhausted.
It is fathomless, the elixir of Life,
The Source of all things.

It manifests to harmonize and unite.
I do not know how it was given birth.
It precedes the concept of God.

How are you resourceful?

Acceptance

The Tao takes no sides;
It gives birth to good and evil.
The Wise take no sides;
And welcome good and its absence equally.

The Tao is like a bellows:
Empty, yet infinitely inexhaustible.
The more it is used, the more it produces,
Whereas speech exhausts understanding.

Stay grounded in the center of Wisdom.

Are you a friend of both good and evil? Do you take sides? In what areas of your life is acceptance most challenging? In what ways would you like to feel more accepted? How would you like to accept others more? For you, what is unconditional love? For whom or what do you express unconditional love?

Love

The Tao never dies.
It is the Great Mother,
Which gives birth to infinite worlds.

Forever and inexhaustibly present within you,
Effortlessly, it can be put into practice for any use.

How best do you express your love, for whom or for what? In
what ways would you like to express your love more? What is the
value that you place on your love? What is the creative purpose of
your love? What kind of world would you like to create and how do
you put it into practice?

Detachment

The Tao is eternal and complete.
Why can it be eternal?
It was never given birth to
And so it cannot die.
Why is it complete?
It maintains no desires for itself;
And so it is present for all beings.

The Wise put themselves last
Yet find themselves ahead.
Detached from the world,
The Wise are one with the world.
The Wise, in letting go of themselves,
Are perfectly fulfilled with themselves.

What experiences have been difficult and easy for you to detach from? And why? What would you like to let go of in order to move on?

Personal Contentment

The highest good is like water,
Nourishing and benefiting without trying.
It flows in low places that others disdain.
And thus, like the Tao,
The Wise remember:

In dwelling, keep close to the ground.
In thinking, embrace what is profound.
In conflict, be fair and love humanity.
In communicating, hold to the truth.
In governing, honor order and peace.
In working, be competent and enjoy.
In action, be timely.

When one is content with oneself,
Without comparison or competition,
There is no blame.

How are you content? In what ways would you like to be more comfortable? Can you embrace the path of peace?

Personal Truth

Fill the chalice to the brim
And it will spill.
Ever sharpen the blade,
And it will blunt.
Accumulate great wealth,
But know it's difficult to protect.
Know when it's enough
In honor, wealth, and pride
To divert one's downfall.

Do the work, then step back.
This is the Tao and the path to serenity.

What is pleasantly sufficient about your lifestyle? What is of abundance? What do you fear is insufficient? Can you do what needs to be done, detach yourself from it and find serenity?

Virtue

Can one coax the mind from its wandering
And center oneself in original oneness?
Can one observe suppleness through breath
And become like a newborn child?
Can one cleanse the inner vision
Until only the light is seen?
Can one love the people and govern
While remaining impartial?
Can one be receptive and still
With the comings and goings of life?
Can one renounce one's understanding
And thus be enlightened to all?

Giving birth and nourishing,
With no thought of possessing,
Doing with no expectations,
Leading not controlling,
This is supreme Virtue.

Can you meditate? Will you be at one with life? Can you cherish a vision of yourself? What do you like about yourself? In what areas of your life can you better align with virtue? Can you be unprejudiced? Do you want to be less controlling? Can you let go of all?

Usefulness

A wheel is made up of spokes,
But its usefulness is in space
That it does not occupy.
A vessel is made up of clay,
But it's the empty space
Within that makes it useful.

A house is made of walls, windows, doors,
But its space
Is what makes it useful.

It is in existence,
That one benefits from the tangible,
But it is the intangible that makes existence of value.

What does your spirit say about you? How do you replenish your spirit?

Inner Trust

Colors make blind the eyes.
Sounds deafen the ears.
Flavors dull the palate.
Mental activity accelerated maddens the mind.
The pursuit of desires difficult to acquire corrupts.

The Wise One observes the world,
But trusts the inner vision,
Allows all things to come and go
And becomes One with the universe.

What is your inner vision? Who are you? What is your true self? What does your inner voice tell you about harmonizing your inner vision with the world? How do you know when to step back and allow things to come and go? Do you trust your inner vision?

Balance

Both success and disgrace
Are sources for concern.
What is valuable and what is fearful
Are within oneself.
Why are good fortune and disgrace
A source for concern?
In its gain, there is a chance of loss.
In its loss, there is dismay.
The Wise stand firm
And keep balance.

What does it mean:
"What is valuable and what is fearful
Are within oneself...?"
Thoughts are phantoms
That arise from the self.
If one did not have a self,
What would there be to fear?

Value the world as oneself
And be entrusted with its governing.
Love the world as oneself
And be entrusted with its care.

With others, how do you express your sense of loss, the release from the feelings of safety and happiness? Can you transform loss into value? Can love guide you in your actions? When letting go of your interactions with others, can you maintain your emotional stability? Can you allow others the same opportunity for growth?

Source of Life

Look, it cannot be seen.
Listen, it cannot be heard.
Reach, it cannot be touched.
The unfathomable describes the One.

Above is not bright.
Below is not dark.
Continuing, unceasing.
It cannot be defined,
Only revealing itself
In the world of the unseen.
The form of the formless,
The image without image,
Beyond conception.

No face, no beginning,
No back, no end.
The Elusive Mystery.

The Wise adhere to the Tao
And govern the present.
The origin of wisdom
Begins with the Timeless Tao.

Are you acquainted with the world of the unseen? Does wisdom guide you?

Patience

The Wise Ones of old
Were profound in their understanding,
Subtle and deep, beyond comprehension.

All we can describe is their appearance:
Cautious, as someone crossing thin ice;
Alert, as someone fearing danger;
Polite, as someone who is a guest;
Yielding, like melting ice;
Unpretentious, like an uncarved block of wood;
Open, like a valley;
Obscure, like the murky water in a pool.

Who can wait quietly
Until the mud settles and the water clears?
Who can remain unmoving
Until activity comes back to life?

The Wise do not long for fulfillment;
Not expecting, not seeking,
Present to the ever-changing Tao,
Its renewal and completion of the self.

What is the tempo of your life? Can you accept the timing of your life and the tempo of others? When are you patient? How do you experience being patient? What enables you to be patient? In what areas of your life do you want to learn more patience? Can you live in the moment and find stillness?

Stillness

Empty the self to attain passivity.
Embrace both stillness and peace.
While all things stir,
Contemplate their return.

Returning to the Source
Is called peace
And living this Eternal Law
Is Enlightenment.

Not realizing the Source
Causes sorrow and misfortune.

When one knows the Eternal Law,
One becomes tolerant;
Being tolerant,
One becomes impartial;
Being impartial,
One becomes dignified
And being dignified
Is obtaining divinity:
Oneness with Tao.
The Tao is Eternal;
Free from danger,
There is nothing to fear.

Can you align yourself with the Source? Are you free from danger?
If not, how are you unsafe? In what aspects of your life or relationships
would you like to experience more of a sense of worth? In what areas
of your life do you find peace? How do you know all will be well? Is
stillness your friend? Are you dignified?

Ability to Trust

The best ruler is one who exists
And the people are barely aware.
Next is a leader who is loved.
Next is a leader who is feared.
And the worst, the ruler who is despised.

If one has no faith in the people,
They become untrustworthy.

The best ruler values words and says little,
Acts so that when the task is accomplished,
The people say, "We have done it ourselves."

When and how do you accept to trust in your life? What lessons about trust have you learned? How does love influence these lessons learned? How do you influence the world through love? In what ways are you a leader? What is your leadership style? Are you the kind of leader who is respected? Do you trust yourself?

Structure

When the Tao is forgotten or abandoned,
Goodness and duty spring forth.
When knowledge and cleverness appear,
So does hypocrisy.
When family relations are not harmonious,
Respect and devotion arise.
When a country is in chaos and falls into misrule,
Loyalty is praised.
When the Tao is lost,
Offered are all the differences of things.

What relationships in your life need to be structured? What would that structure be? What needs to be addressed concretely to fulfill you emotionally?

Temptation

Do away with knowledge and cleverness
And the people will be a hundred times happier.
Get rid of goodness and duty
And people will return to their natural affections.
Banish industry and profit
And there will be no thieves.

And if these are not enough:
Look to the pure,
Keep to the simple,
And curb one's desires.
Remain in one's center
And harmony will reign.

What temptations attract you? What in your childhood brings back deeply held memories of loss and deprivation? Do you know how to replace these memories with self-love? Can you find the support to nurture self-love? Can you find joy in the simplicity of life?

Sustenance

Detach from worrying.
Between yea and nay,
How much difference is there?
Between success and failure,
What is the distinction?
Must one fear
What others fear?
Nonsense,
Uncenteredness disguised as fear.

Others are joyous.
I, alone, am still,
Expressionless,
Like a baby before it can smile.
I, alone, am forlorn,
As one who has no home.

Others all have more than enough.
I, alone, appear to possess nothing.
I, alone, have the mind of a fool,
Muddled and confused.

Others are bright.
I, alone, am dull.
Others are knowledgeable and self-assured.
I, alone, am negligent,
Obscure, drifting, attached to nothing.

Others have a purpose.
I, alone, seem impractical and useless.
I am different from others,
I know and value sustenance from the Mother.

What sustains you when you feel you are without a sense of purpose in the meaning-making of your life? What in your life keeps you safe and happy?

Self Knowledge

The Wise remain
At one with the Tao,
The mark of great virtue.

The Tao is elusive and invisible.
Subtle, and yet it contains
Within itself an essence of all that is,
And an unfailing sincerity.

Throughout the ages,
The Tao has been preserved
To know the origin of all things.
How does one know this?
By the nature of the Tao within.

Are you a sincere person? Through time, what have you learned about yourself? What has given you a sense of self-worth? How will you fulfill your life? What would you like to experience that would bring you closer to the Tao? Have you looked inside yourself?

Wholeness

To become whole,
One must yield.
To become straight,
One must bend.
To become full,
One must empty.
To become reborn,
One must die.
To be given everything,
One must give up all.

The Wise embrace the Tao
And become a model for the world.
Because the Wise do not display,
The light can be seen.
Because the Wise need not to prove,
Credit is given.
Because the Wise do not boast,
Recognition is bestowed.
Because the Wise do not compete,
Peaceful competence is assured.

When the sages of the past say,
"To become whole, one must yield,"
Can these be regarded as empty words?
In yielding to the Tao,
The Wise return to wholeness
And all things return to the Tao.

In what areas of your life do you feel that something is missing?
Do you know your vulnerabilities? What have you given up in order
to live more fully? Did or do you feel safe and happy in the void? How
can you with integrity bring yourself into a community of joy? When
do you know to yield?

45

Vibrant Identity

Express oneself,
Then maintain silence.
A whirlwind lasts not the whole morning,
A rainstorm lasts not the whole day.
Nature does not have to insist.
Humanity does not have to insist.

One who follows the Tao
Is at one with the Tao.
One who follows character
Is at one with character.
One who thus abandons the Tao
Is identified with abandonment.
The Tao is welcoming,
Character is welcoming,
Loss is welcoming.

Lack of faith does not command faith.
One who follows faith is at one with faith.
Faith is welcoming.

What gives you strength of purpose? How do you communicate
your needs? How do you handle change? Are you the victim of change
because you are afraid of letting go? Or are you accepting of change
because you embrace the opportunity for growth? Have agreements
been honored in your relationships? Are you compassionate toward
yourself? Do you have faith?

Pride

One who stands on tiptoe
Does not stand firm.
One who strains to stride
Does not walk forward well.
One who boasts
Is not given credit.
One who glorifies the self
Is not respected.
Boasting and parading
Have no merit
And will not endure.

The Wise do not
Set their heart upon excess
But remain simple
In the Way.

How does pride influence your life? What excesses do you have?
Are you rushing? Do you feel the need to give yourself credit? How
can you be more at peace and enjoy your life? What relationships or
activities speak to your heart? In what ways can you appreciate simply
those relationships or activities?

Origin of Power

Before Heaven and Earth were born,
Solitary, nebulous, silent
Unchanging,
Worthy to be the Mother of All Things,
Name unknown,
The Wise gave the name Tao,
Eternal and Great.

Greatness reaches far
As it goes on
And as it returns,
It is the origin
Of All Things.

The Tao is great.
The Universe is great.
Earth is great.
Humans are great.
Four great powers
Of which women are one.

Humans follow the Earth.
Earth models Heaven.
Heaven models the Tao.
The Tao follows itself.

What is your greatest joy? How do or can you manifest it? Do you
feel your own power?

Stability

Solid is the source of light.
Stillness is the root of movement.

Therefore, The Wise travel all day,
Yet never leave home.
However splendid the sights,
They remain at ease,
Undisturbed.

Should then The Wise
Act frivolously?
In frivolity,
The foundation is lost.
In hasty action,
The center is lost.

What gives you the greatest sense of stability? What knowledge gives you a strong sense of self? Can self- knowledge make you more stable? How does this knowledge empower you? What type of relationship makes you feel secure? What type makes you feel insecure? In what ways have you been frightened by others? Do others frighten you now? To maintain the wisdom of your stable path, what have you given up or do you need to give up?

Openness

A good and skillful traveler leaves no tracks.
A good and skillful speaker
Seeks no applause.
A good and skillful accountant needs no counter.

A good closure needs no bolts
And yet it remains closed.
A good fastener needs no knots
And yet it remains connected.

The Tao helps humans.
Humans are not rejected.
The Tao is a good savior
Of all things
And nothing is rejected.

The good
Teaches the bad
And the bad
Is the resource of the good.

Not to revere one's teachers
Or value one's resources
Is to err, however intelligent.
This is the subtle mystery of the Tao.

Are you an artist of life? Are you open to and do you welcome learning the lessons of your life? Who are your teachers and what are your resources? Can you learn to value your teachers and your resources?

Foundation

Knowing the masculine
While keeping to the feminine
Channels virtue
And returns to Innocence.

Knowing the white
While keeping to the black
Becomes a model for the world
And returns to the Absolute and Freedom.

Knowing honor
While keeping to humility
Receives the world
And returns to Wholeness.

Primal Energy in its Simplicity is diversified
And thus becomes useful.
The Wise know the usefulness of tools
While keeping to the simplicity of Being.

Do you honor your "being" in the relationship? Is the foundation of your relationship built upon a deep connection? Or is the connection good enough? Is the relationship based on a mutual exchange of good will? Is love the basis for the interaction? As an innocent gesture, do you give from all of your worth?

Release

Is the world to be improved?
It cannot be done.
The world is a sacred vessel.
Not shaped or insisted upon.
Shaping spoils,
Insisting loses.

There is a time for going ahead,
A time for following behind,
A time for breathing slow,
A time for breathing fast,
A time for growth,
A time for decay,
A time to be up,
A time to be down.

The Wise avoid excesses
And extremes
And reside in the center
Of peace and harmony.

How do you know when to release and change the tempo of your life? When you are in a relationship that you have decided no longer provides you with a sense of worth or warmth, do you know how to gently release yourself from the relationship? Can you find a sense of peace in that decision? Can you accept that it may take time to heal after a relationship has ended? Can you be patient with the process of discovering a new joy?

Purpose

The Wise who rely on
The Tao in governing
Do not override the world
By force of arms.
Force rebounds and
Scarcity follows.

The Wise do their job,
Affect purpose and stop.
What is against the Tao
Soon comes to an end.

How do you respond if your contributions to affect purpose are thwarted?

War and Peace

Weapons of war
Are implements of death.
They are not tools of the Tao.
The place of honor in life
Is the left.
The place of honor in strategy
Favors the right.

As weapons are instruments of death,
Necessity is the only call
To resort to them.
Peace is superior
And the way of the Tao.

Observe victories
As observing a death,
With sorrow, compassion and mourning,
As at a funeral.

What is worth fighting for in your life? What do you care for deeply? What is the peace that you want?

Harmony

The Tao is nameless,
Small, simple,
Yet commands all.

If powerful women and men
Would abide by the Tao
All would be at peace.
Heaven and Earth would join
In harmony.

Names appeared
Through the diversification
Of Energy.
The Wise who know
To stop and be still
Are exempt from danger.

Oceans are at one with the Tao
As rivers run into the sea.

Are your relationships harmonious? Which of your relationships are harmonious? How is your joy supported in that relationship? If there is not compatibility, can you forgive the emotional worth of those concerned in order to find and respect the qualities of safety and happiness in your relationship? Can you both value winning through the depth of connection you have for each other?

Fulfillment

One who knows others is learned,
One who knows self is enlightened.
One who governs others is mighty,
One who governs the self is stronger yet.
One who is contented is rich.
One who is determined has purpose.
One who remains centered endures.
And one who dies, but does not perish
Lives forever.

What fosters the fulfillment of your life: mastering the self or governing others? Are you content? What is your purpose? Do you have a legacy that you would like to leave? What is that legacy? How do you or would you like to extend your good will in a community of like-minded others?

Giving

The great Tao flows everywhere.
All things come into being by it.
When the work is accomplished,
It does not possess it.
It loves and nourishes all,
It does not dominate.
Without desire,
It may be called small.
Being the home of all,
The Tao does not claim,
And greatness is fully realized.

Do you like to give of yourself? Can you give without receiving anything in return? How do you feel when you are giving and receiving from the heart? How do you generally feel when your offerings are received? Do you share with a full heart?

Illusions

The Wise who are in accord
With the Way
Follow without harm,
Keeping to safety, health,
Community, and peace.

The sensual pleasures
May make people stop and enjoy.
The words of the Tao,
Though mild and flavorless,
Unappealing to the eye and the ear,
Possess lasting effects.

What keeps you safe? How does the innocence of your joy keep you from feeling safe? Do you place a value on yourself? Do you have any illusions about your worth? In a relationship, when and how do you define and realize your worth? Is your self-worth important to you? In your relationships, can you forfeit comfort and depth of feeling to realize a relationship based on being safe and happy?

Polarity

What is to be shrunken,
Begins by being stretched.
What is to be weakened,
Begins by being made strong.
What is to be laid low,
Begins by being exalted.
What is to be taken away,
Begins by being given.

This is subtle wisdom.
Softness and weakness
Overcome the hard and strong.
The mystery offers itself
Without the display of weapons.

Does the nature of time assist you in learning about yourself in a deeper way? Do you experience the polarities of life, both in desired as well as unwanted change? Can you view the polarities of life with the potential of adding meaning to your experiences? How do you view the polarity of man and woman? Can you find love everywhere including within yourself? Can you play with the polarities of receiving and giving love? Can you allow other people to have their dignity in their depth of connection with you? Are you able to return to your softness?

Contentment with Relations

The Tao takes no action
And all things are done.
If powerful women and men
Were centered in the Tao
Free from desires,
The world would find peace and harmony
Of its own accord.

As a woman, when are you happiest? What is your joy? What relationships fulfill you and why? In a relationship, do you let time be a factor in learning about each other as a woman and man? Do you want to be content and feel free from desires?

Ambition

Not conscious of virtue,
The Wise are truly virtuous.
Devoid of character,
One reaches to possess it,
Thus never has enough.

High virtue has no intentions.
Inferior virtue has private ends to serve.
Service acts without a motive.
Justice acts with a motive.
Righteousness acts with a motive
And when there is no response,
Force is used.

When the Way is lost,
The doctrine of humanity arises.
When the doctrine of humanity is lost,
Justice arises.
When justice is lost,
Righteousness appears.
When righteousness is lost,
There is ritual.
And without knowledge of the Tao,
Only the edge of loyalty and trust remains,
The onset of confusion and Chaos.

The Wise keep to the solid,
Not to the tenuous,
Upon the fruit rather than the flower,
Preferring what is within to what is without.

How do your motivations influence your ambitions? And how do
your ambitions represent you?

Health

In mythological times
All things were whole.
Possessed of Oneness
Heaven is clear,
Earth is stabilized,
Spirits are divine,
Valleys are full,
Creatures regenerate,
Rulers are at peace.

Without Unity,
Heaven is filthy,
Earth is unstable,
Spirits are unresponsive.
Valleys are barren,
Creatures die,
Rulers fall.

Humility is the root
From which greatness springs.
The lofty find stability in lowness.
The Wise view with compassion
Parts of the whole
And are shaped by the Tao;
Common as stone,
Not shining like a jewel.

How do you influence the health of the world? How do your
emotions reflect illness or health? With humility and self-compassion,
do you desire to let go of any ailments? How do you attack your
own body? As a child, were you ever frightened? Can you relinquish
that fear? Have you experienced the feeling of being loved? Can you
release relationships that do not support your well-being? Can you
wait for love? Do you love your own self-worth?

Birth of the Unknown

Returning is the motion of the Tao,
Softness is its function.
All things born are of being;
Being is born of non-being.

In what ways do you return to Oneness? Have you ever experienced your silence? When do you enjoy your stillness? Do you fear the innocence of joy? What steps do you take to reduce your stress? How do you let the Unknown create softness in your life?

Mystery

When a wise person hears of the Tao,
It is put into practice quite diligently.
When an average person hears of the Tao,
It is sometimes practiced and often ignored.
When the confused person hears of the Tao,
It is laughed at boisterously.
If the confused person did not laugh at the Tao,
Would it still be the Tao?

The Wise of old say:
The bright Way looks dim.
The progressive Way looks retrograde.
The smooth Way looks rough.
The straight Way looks circuitous.
The simple Way looks changeable.
The great Way looks meek.
Great squareness has no corners,
Great talents ripen late,
Great sound is silent,
Great form is shapeless.

The Tao, hidden and nameless,
Alone nourishes and completes.

As a woman, how does the mystery of you shape your interactions with men? How do men respond to the enigma that reflects your spirit? Is there a man who wants to court you and is not afraid of you? Are you prepared to let him in? Are you happy about this creation? What do you desire? How do you communicate through your heart these desires? Are men afraid of you? Is their vulnerability causing a lack of movement in the relationship? Can an arrangement be made which is mutually supportive? Can you allow grace into your life and the lives of others?

Honor

The Tao births the One.
The One gives birth to Two.
The Two gives birth to Three.
And Three gives birth to All.

All things are backed by the feminine
And face the masculine.
When the masculine and the feminine combine
Through union,
Harmony is the Way.

Orphaned, lowly and alone
Are the Wise rulers
One with the Universe.
So with loss, much is gained
And with gain, much is lost.
The primary teaching:
Violence is the violent death.

How do you feel when a man exhibits his emotional worth to you, when he shows you visible signs of his value? Are you interested in him? Do you appreciate the way he may want to honor you? Do you respect yourself as a woman? Is the esteem mutual? Can you let your spirit guide you in this relationship? If you are in a relationship, can you as well as he release any buttons either of you may have about sharing a physical life together? If the relationship does not support who you are, can you gently let it go and be yourself? Can your spirit find a higher calling? When ending a relationship or potential relationship, are either parties feeling angry? If so, what is at the root of your anger? Can you forgive yourself when your buttons are pushed?

Artistry

The softest overrides the hardest.
Only nothing enters into no-space.
This is the benefit of non-action.
Wordless teaching and unattached action
Are the Way of the Wise.

Do you let your feminine spirit be your guide? Can your spirit show you the way toward softness and non-action?

Expectations

Fame or one's life:
Which is more valuable?
Possessions or integrity:
Which has more worth?
Gain or loss:
Which is more harmful?

Great love extracts great cost
And true wealth requires greater loss.

Therefore be content
And not disappointed.
Know when to stop
And avoid danger.
Endure long.

How do your expectations influence your life? What are your expectations in order to realize your emotional make-up? How do you measure your self-worth? How do you know success? How do you know frustration? Does courtship lead to love? Does love require commitment? What type of commitment is necessary to keep each other safe and happy? Without a substantial commitment, can you find a way to be content and avoid danger?

Competence

The greatest perfection
Seems imperfect,
Yet it is never exhausted.
The greatest fullness
Seems empty
Yet never runs out.
True straightness
Seems directionless.
The greatest talent
Seems awkward.
Great eloquence
Seems stammering.
Excitement overcomes cold,
Stillness overcomes heat.
Who is calm and quiet
Becomes the guide for the universe.

How do you know competence?

Fear

When the world lives
In accord with the Tao
Horses are given productive uses.
When the world
Goes counter to the Tao,
Horses are bred for war.
There is no greater curse
Than lack of contentment
And indulging in greed.
One who knows
What is enough
Will always have enough.

What do you provide either in quality, in form, or both? Are you susceptible to greed? Do you have any fears? What do you fear? What are you prepared to defend? Do you feel that the love or good will in humankind or a portion of the human race has been severed? Is the duration of the Void or the Unknown experienced by the affected population generating fear in you? How is this unpleasant emotion caused by the anticipation or awareness of danger threatening to you? Do you have enough of what you need? What do you need? What is enough? Are you content with your life? What do people need to be content? Is it possible to meet the needs of everyone? How can the needs of everyone be met? How can all those involved be safe and happy?

Presence

Without going out the door
One can know the world.
Without looking out the window
One can see the Tao.
The further one seeks
The less one understands.
Thus, the Wise
Know without traveling,
Understand without seeing,
Accomplish without doing.

Are you involved with a community that respects you for who you are, without needing to be special or different? Does that community and your more intimate relationships meet your emotional needs? Is it necessary to look elsewhere?

Non-Action

Learning consists of accumulating.
Practicing the Tao consists of decreasing.
The Taoist decreases
And continues to decrease
Until arriving at non-action;
Through non-action everything is done.

To win the world
One must renounce all.
With private ends to serve,
One will never win the world.

What have you accumulated? What have you practiced decreasing? What through non-action have you wanted to accomplish? What have you given up? Can you release your sense of community, which is based on money, and replace it with a community, which is based on humanity?

Gifting

The Wise have no self to call their own,
But take the interest of the people
As their own.

Good to the good,
Good to the bad,
This is goodness.

Faithful to the faithful,
Faithful to the unfaithful,
This is faithfulness.

The Wise live in the world
In harmony.
People strain their ears and eyes:
The Wise look onto them as their own children.

Do you look for love everywhere including within yourself? What is the gift you give to others? Do you welcome harmony into your life?

Death

On leaving life
Death enters.
Thirteen are the companions
Of both life and death
And which are met both the same.

One who walks in life
Without illusion
Meets not with danger.
One who walks into battle,
Without illusion
Is not touched by weapons,
For death holds no fear.

Thirteen are the companions of life and death: the limbs and orifices of your body – How do they guide you? Do you accept the ebb and flow of existence? How do you feel about dying? Do you live in fear of death? What illusions do you have? How do you live in danger? How can you change your illusions into Truth? Can you verify and honor the lessons of your life and illuminate yourself? Do you use your companions to assist you?

Nurturing

Tao gives life,
Virtue nurses life,
Matter shapes life,
Environment perfects life.
Life honors the Tao.

When the Tao is honored
By accord, not by command,
Esteem of Virtue is complete.
The Tao gives birth,
Nourishes, shelters, cultivates
And protects.

It gives birth,
But does not own.
It acts without attachment.
It serves without expectation.
It leads without dominating.
This is mysterious Virtue.

Who keeps you protected and honored in life? Who do you protect and nurture in life? How do you nurture, and how do you like to be nurtured? Even though questions may arise about the continued unfolding of a relationship, will you respect the qualities of the relationship to mutually support safety and happiness?

Enlightenment

All in the world
Has a common beginning.
This is the mother.

To find the origin
Trace back the manifestations of life.
When one recognizes the children
And knows the mother,
One is free from sorrow.

Contemplate the Tao.
Accept all things
Without distinctions or judgments.
Life is without toil.

Contemplate confusion.
Criticize all things.
With worry and judgments,
Life remains helpless.

Use light with illumination
And create no harm.
This is following the Tao.

As a woman, do you accept yourself in your own humanity?
Without needing to feel special or different in your relationships, do
you feel unconditionally accepted? How do you release confusion?
How do you express your own light?

Confusion and Greed

To be illuminated
Is to follow the Tao
And fear only straying from it.

The path of the Tao is easy,
Yet people prefer devious paths.
When leaders and the rich prosper,
Accumulating wealth for the sake
Of accumulating wealth,
This is not in keeping with the Tao.

Are you guided by higher values or by confusion and greed? Do you consider yourself to be a "have" or a "have-not" or a "have-not-yet"? How do you value your resources? How do you share your treasures? How do you see people who are affluent and those who are not? What would you like to do with your wealth? How would you like to become prosperous?

Self-Respect

Whoever is planted in the Tao
Will not be uprooted.
Whoever embraces the Tao firmly
Cannot be loosened.
Generation to generation
Will carry the Tao in honor.

Developed in the individual,
Character will become genuine.
Developed in the family,
Character will become abundant.
Developed in the community,
Character will multiply.
Developed in the state,
Character will prosper.
Developed in the world,
Character will become universal.

Therefore, according to the character of:
Observe the individual,
Observe the family,
Observe the community,
Observe the state,
Observe the world.
How does one know this observation to be true?
By knowing oneself.

Do you respect yourself? How is your self-respect demonstrated through your actions? If you would like more self-respect, what would that look like? How would you like others to respect you? How do you respect others individually, in your family, in your community, in your country and around the world?

Fortitude

One who is filled with Virtue
Is like a newborn child
And is protected from harm;
Its bones soft, muscles weak,
But its grip firm.

It has not known the union
Of male and female,
Yet the organs are complete
And vitality plentiful.

It screams all day
Without growing hoarse;
Knowing the breath,
It embodies perfect peace,
The eternal changeless endures.

To hasten the growth of life is ominous.
To control the breath by will is to strain.
All that is against the Tao,
Through haste, decays and ends early.

Do you tend more to expedite, delay or easily move with the changes in your life? Are you focused, yet peaceful in your pursuits? In your relationships, do you continue on in spite of setbacks in order to mutually find a way to manifest love?

Countenance

Those who know
Do not speak.
Those who speak
Do not know.
Stop talking,
Meditate in silence,
Soften the light,
Release worries,
Merge into wholeness
With the Source of the Tao.

The Wise, not attached
To affection or estrangement,
Profit or loss,
Honor or shame,
Endure continuously
And therefore is highest of the world.

When love is not returned in your relationships, can you maintain your sense of self? Can you feel the connection and let go of the relationship or the communication with dignity?

Self-Reliance

Govern by the Tao.
War by strategy.
Win the world by letting go.
How does one know this?
The more restrictions,
The poorer the people.
The sharper the weapons,
The greater the chaos.
The cleverer the people,
The more cunning exists.
The greater the number of laws,
The more thieves arise.

Therefore, the Wise say:
Make no fuss
And the people transform themselves.
Love tranquility
And the people correct themselves.
Do nothing
And people grow rich.
Have no desires
And the people return to simplicity.

How do you use your mind to move toward manifesting a safe
and happy life for yourself? Do you value self-reliance? Can you
release the immediate need for joy to follow a more profound path?
How do you see yourself in five years? How do you currently rely
upon yourself to live simply? Are you happy with yourself?

Adversity and Tolerance

If a country is governed by tolerance,
The people are simple and happy.
If a country is governed by strictness,
The people are discontented.
Good fortune is the harbinger of disaster,
And adversity is the foundation of good fortune.
What is the ultimate end of the process?
Normal turns deceitful,
Auspicious turns ominous.
This has long led humankind astray.

Therefore, the Wise remain:
Firm, but not cutting,
Honest, but not hurtful,
Straightforward, but not imposing,
Illuminated, but not glaring.

How do you direct yourself? How are you governed? How do
you view success? Can adversity bring you good luck? How do you
see others in their adversity? Do you let others find their way? Are
you tolerant of their journey?

Moderation

In governing,
The Wise use moderation.
Moderation is to have conformed
Early to the Tao
With an intensive accumulation of Virtue.
Virtue is to overcome everything
And reach an invisible height.

Like the mother
Who provides
And endures long,
Deeply rooted,
Firmly based
In the Tao,
Holding lasting life
And eternal vision;
This is the road to the Way.

What do you need to moderate in your life? Will you replace any excesses with a supportive vision that enhances who you are? Can you be your own champion? Will you foster self-encouragement? How do you feel when your heart is filled with self-love?

Subtlety

Ruling a large country
Is like cooking a small fish,
To be handled delicately.
If in accordance with the Tao,
Evil will lose its power.
Not that spirits will have no power,
But the powers will not be harmful,
As the Wise do not harm people.
Evil, given nothing to harm,
Disappears by itself.

Do you connect with others on a deep soul level? Can you see through darkness? Will you support the self-worth of other people even if they are angry in their darkness? Can you claim your own light for yourself and surmount the negative influence? Are you hurtful? Do you use your energy in dishonest ways? If approached by corruptive powers, or if you induce malevolence, how subtle are you in extracting yourself from harm?

Empowerment

A great country is like a lowland
Toward which rivers flow.
It is the reservoir of the world,
Like the feminine to the masculine
Which by quietness conquers.
Hence, a great country
By lowering itself
Before a small country
Will be allowed to govern it.
And when a small country
Lowers itself to a great country,
It will gain by it.
Thus, some lower to take,
While others lower to gather.

The desire of a big country
Is to shelter others.
The desire of a small country
Is to be sheltered.
To obtain one's wishes,
The greater one must yield.

In your intimate relationships, do you mutually recognize and honor the nature of feminine and masculine energies in each other as a woman and man? To what degree in your relationships are you comfortable and joyful in being a woman? In your partnership, is there an imbalance of feminine and masculine energies? Do you wish to shelter, be sheltered, both, or neither? Do you compromise in relationships, do you find yourself compromised, do you create win-win relationships, or none of the aforementioned? Do you prefer to tame, be tamed, play at a little of both, or not participate? In a relationship with your significant other, are you empowered to be feminine? Are you happy as a woman?

Forgiveness

The Tao is the hidden reservoir of all things.
A treasure for the good,
A refuge for the bad.
Fine words can be marketed,
Good deeds can be gifted,
But the Tao, beyond value,
Rejects no one.

Thus, when a new leader is chosen,
Offer the Tao.
Why did the ancients esteem the Tao?
By seeking its Virtue,
The Tao is found
And faults are forgiven.
This is its treasure.

Have you learned to forgive the worth of both yourself and others? Do you know when forgiveness is asked of you? Can you release the depth of feeling you have for each other and replace it with seeing love in one another to promote joy? When choosing to be receptive to follow someone, how do you express to this person the manner of care you wish to enjoy? Is there an understanding and agreement about that care?

Challenges

Act by non-action,
Strive for the effortless,
Savor the savorless.

Exalt the low,
Multiply the few.
Remedy injury with kindness.
Manage the difficult while still easy,
Manage the great while still small.
All difficult things start easy,
All great things start small.
Thus, the Wise never strive
For the great,
Thereby greatness is achieved.

One who lightly makes a promise
Will find faith hard to keep.
One who thinks everything easy
Will foster difficulty.
Thus, the Wise one regards
Everything as difficult
And so never has difficulties.

How do you accept your challenges? What emotions do challenges
evoke in you? Do you invite love into your life to guide you through
your questions?

Preparation

What is still is easy to hold.
What hasn't begun is easy to plan.
What is brittle is easy to break.
What is small is easy to scatter.

Prevent trouble before it exists.
Create order before confusion arises.
The tallest tree grows from a tiny sprout.
The greatest journey starts beneath one's feet.

One who controls, spoils. One who grasps, loses.
The Wise never control nor spoil,
Never grasp nor lose.

Confused people usually spoil things
Just short of success.
In handling affairs, take care with the end
As with the beginning and nothing will be spoiled.

Therefore the Wise, free from desire,
Place no value on rare goods, learn to unlearn,
And help humankind remember its Oneness
With the Tao.

What needs preparation in your life? How can you create order?
Can you handle your affairs in the end as in the beginning? Even as
people change and grow, can you foster the depth of your connections
with others? What has the potential of spoiling? What needs nurturing
in your life? Can you express clearly what you care about deeply? Can
you release your desires? Will you assist others in being at One with
the Tao?

Simplicity

The best practitioners of Tao
In olden times
Did not use the Tao to awaken
People to knowledge,
But used it to restore
People to simplicity.

When people think they know the answers
They are difficult to guide.
When people do not know,
They can find their own way.
To govern,
The simplest pattern
Is the clearest.

To know these two principles
The Wise rule and measure
And keep always in mind
The standard of Subtle Insight.

Deep and far-reaching,
Subtle Insight
Returns all things
To peace and harmony.

How do you simplify your life? When relationships are out of balance, do you know whether to guide or to be guided? Do you let peace and harmony lead you in your communications? Can you let others find their own way when necessary and still appreciate them?

Humility

How does the sea rule the rivers?
All streams flow to the sea
As it is lower.
Humility gives it its power to rule.

Thus the Wise to govern
Must speak humbly,
And to be ahead,
Must be behind.

Thus the Wise above
And the people are not oppressed.
The Wise lead
And no harm comes to the people.
The world is grateful
To the Wise.
The Wise do not compete
And no one opposes the Wise.

Do you acknowledge people who extend their love to you? Or do you feel superior to others? What is your sense of timing? As a woman, are you valued in your relationships? Or do you intuit as if your significant other has an imbalance of pride and sense of greatness that prevents their desire for interdependence and their humble acceptance of their own humanity? Will you nurture their humility and your own? Do you measure the success of your life by comparing it with the prosperity or achievements of the lives of others? Can you gently support your relationships and your community in the giving and sharing of love?

Compassion

The Tao is great
Like nothing on Earth,
The world says.
The Tao is great
Just as nothing on Earth,
Otherwise it would not be true.
It would be small.

Three treasures
The Wise guard:
Love, moderation, and patience.
Through love,
The Wise have no fear.
Through moderation,
The Wise are giving.
Through patience,
The Wise contain the world.

Without knowing
These treasures first and foremost,
One only courts death.

In attack and in defense,
Love wins.
Heaven saves and protects
With love.

Do you value compassion? How do you express love, moderation and patience in your life? Are you joyful in your compassion? If currently if a relationship, is there a need for more love, moderation and patience? How are you compassionate toward yourself? How do you show compassion toward others? How do you feel when you give and receive compassion? Can you share your physical life with another?

Non-Competition

The brave soldier is not violent;
The good fighter does not use anger.
The best conqueror does not engage in battle.
A good leader serves under those who follow.
This is called the embodiment of non-competition,
Using the abilities of people
Through non-striving
And consorting with heaven
Like the sages of old.

Do you want to compete to ensure your value? Is competition important to you? Do you feel the need to compete with others in order to feel safe and happy? Is playful competition a better alternative in the enjoyment of life? Is the desire to employ the use of others' abilities more effective in furthering accomplishment than the need to win out over others?

Gain and Loss

Strategists have a saying:
Dare not be a host,
But rather a guest;
Dare not advance an inch,
But retreat a foot.
This is called movement
Without advancement;
Pushing back
Without needing to confront.

There is no greater misfortune
Than to underestimate the enemy.
To underestimate the strength of the enemy
Is to forsake one's three treasures.
Therefore, when opposing forces
Engage in conflict,
Victory belongs to the grieving side.

In conflict, what do you want to gain? What do you have to lose? How best is it to communicate your truth? Can your communication be based on love, moderation and patience? Can you resolve your differences while honoring yourself? What does the other want to gain and have to lose? What will be lost in conflict?

Secrecy of the Heart

These teachings are
Easy to understand and practice,
Yet the world cannot understand or practice.
There is a principle
And in human affairs
There is a system.
Because they know not,
They know not the Tao.
The fewer are they who understand,
The nobler are they who follow.
Therefore the Wise
Appear common
And keep a jewel hidden in the heart.

Do you bear malice toward yourself for your own darkness? Will you forgive yourself? Would you like to realize your own light? Do you have a vision of your life? Can you forgive the relationships in your life that were unfulfilling? Can you find and love the gifts of light that the darkness of past relationships has provided? Do you want to find your own sense of worth and accept your own humanity? What is the secret in your heart?

Self-Healing

To understand that our knowledge
Is ignorance is noble insight.
To regard our ignorance
As knowledge is illness.
Only when we recognize our illness
As an illness do we cease to be ill.
The Wise heal themselves
When they are sick of their sickness.
This is the secret of health.

How do you contribute to your own disease? What in your life needs rejuvenation? Does your body reflect symptoms of a disease? Do your relationships assist you in feeling safe and happy during a process of regeneration? If the relationship is in need of healing, will you keep each other safe and happy during a time of transitions? What do your relationships mirror about this needed restoration? Do you want to alter your relationship to make it more joyful? How do you revitalize your own sense of worth when experiencing illness? Can you let your ignorance guide you in forming questions to ask about the illness? What can be revealed in the darkness? Can you provide answers to these questions that will open the doors to enlightenment?

Self-Ownership

When people lose their sense of awe,
They are overwhelmed by confusion.
Despise not their dwelling nor livelihood.
Respect garners respect.
Therefore, the Wise know themselves,
But make no show of themselves:
Love themselves, but do not exalt;
Preferring what is within to without.

What has experience taught you about self-ownership? Do you love yourself? Do you prefer what is within to what is without? Do you respect yourself? Is the respect you have for yourself reflected by the value others display toward you? Is the respect you have for others mirrored by the regard others exhibit toward you? How can your respect of others be increased? Can you appreciate the qualities of others?

Self-Realization

One who shows courage
In daring will perish.
One who shows courage
In not daring will survive.
In these, one is beneficial,
The other harmful.
The Wise too are even baffled by this question.
This is the way of the Tao:
Win without striving,
Secure responses without speaking,
Invite arrivals without summoning,
Accomplish without planning.
Heaven's net is vast, sparsely meshed,
Yet missing nothing.

Which is beneficial: to evolve, or stay the same? Which is harmful: to live in certainty, or to live in uncertainty? Can you play with others and reveal a vision of your worth? Will you arrive at your own self-realization by embracing a hundred percent the innocence of your joy? Does the Unknown guide you in the unfolding of your life? Will you let your truth be fluid?

Courage

If one understands that all things change
And death no longer frightens people,
Why attempt to control through death?
If one has a life worth living
The fear of death is meaningful
And laws will be abided.

It is the Supreme Executioner's Fate that kills.
Taking the place of Fate,
Or the master carpenter,
Surely chances are
One's self will be injured.

What motivates you to express your courage? What is worth living for in your life? Have you the courage to recognize the worth of your relationships? Do you tempt finality as a way to find your value in your relationships? Do you honor the courage of others? Do you accept that it may take time to rekindle goodwill in relationships? Can you allow the process of change to take its course?

Discontentedness

Hunger,
A result of high taxes.
Rebellion,
Governing with private ends to serve.
Death taken lightly,
People have nothing to live upon.
How is such a life valued?

Are you discontented? Do you appreciate your relationships? Are the people with whom you are in relation meaningful to you? Are your or others' motivations self-serving, born of neediness and distrust? In relationships, do you feel like you are giving more than you are receiving? Do you feel burdened? Do you consider the life of this relationship to be valuable? Do you believe that your life is valuable? Do you accept that your feelings have merit? Is there a way to communicate discontent in order to build a bridge of mutual value? Can you both recognize each other's desires begin to heal the differences in the relationship?

Flexibility

At birth, people are tender and weak;
At death, hard and rigid.
A living plant is soft and tender;
At death withered and dry.
Companions of death, the rigid and hard;
Companions of life, the soft and supple.
An army inflexible suffers defeat,
As dry wood is ready for the axe.
The mighty and great will be laid low,
As the humble and weak will be exalted.

Can you be a companion of life? How flexible are you in learning the lessons of life? Are you open to the nuances of timing and change? Do you receive useful information through new experiences? Can you adapt to changing circumstances? Can you return to your own softness and yield?

Generosity

The Tao of Heaven
Like the bending of a bow:
The top bent downward,
The bottom bent up;
Diminishing the great,
Augmenting the lesser.

The Tao of Heaven
Lessens the abundant,
Gives to the insufficient.
The Tao of people,
On the contrary,
Takes from the insufficient,
Gives to the abundant.

Who can have enough
And give the spare to the world?
The person of Tao.
Therefore, the Wise
Work without hoarding,
Accomplish without dwelling,
Do good, not harm,
And remain humble.

Do you know yourself to be lacking or abundant? In what ways do you feel deficient or blessed? In what ways are you generous? How do you judge the worth of others? Do you like to balance the scales? As a woman, how are you generous? Are you humble in your generosity? What would you like to expand in your life?

Helping

Nothing is softer and weaker
Than water.
But for overcoming
The hard and strong
Nothing is superior.
Weakness overcomes strength,
Gentleness overcomes the hard.
Something known by all, practiced by few.

The Wise say:
One who accepts sorrow
Bears misfortune.
One who releases helping
Is the greatest help.
The words of truth
Appear paradoxical.

Do you want to release sorrow willingly? Do you allow others the liberty to make their own decision of whether or not to move into the Unknown in order to face and transform their Darkness? Can you let go of helping? Do you want to free yourself from another so you can maintain your sense of safety and happiness? Can you gently let others find their own Way? Can you help people by letting them discover their own lessons and their own self-love?

Self-Accountability

When a great wound heals,
A scar still remains.
The Wise keep to their agreement
And lay no blame.
The Wise keep their promise,
The less Wise break it.
The Way of the Tao
Is impartial and perpetuates value.

Do you feel a wound? What is it? Will you assist yourself in healing by asking for a new vision as a woman that will help with your joy? Are you responsible for your decisions and your life? Can you account for and determine the value of your talents, emotions and body? Will you enlighten yourself? Do you fulfill your agreements? When a relationship of depth ends, do you know the promises that were agreed upon? Do you honor your side of the agreement? If others break their promise, will you take action to remedy the arrangement or will you feel victimized? Can you release the other without attachment and as a matter of course, laying no blame or will you feel that it is necessary for you to get even? Can you dispassionately see the situation without attacking? Can you assist in the peaceful goodwill of transitions or endings?

Social Contentment

A small country
With a small population
Governed wisely,
With no use for complicated machinery,
And mindful of death
Will not wander far.

With boats and carriages seldom used,
With weapons not on display,
The population content
With food, clothes and home,
A simple way of living is enjoyed.

And though the neighboring country
Can be heard, the people do not go.

Are you content living in your Country? Would you rather live in another? Are the people you live with mindful of death? Is your country small? Do you feel you are governed wisely? What do you enjoy about living in your country? What do you deeply love about your country? Do you feel like the worth of your nation is being attacked? Are you afraid to forgive men and feel deeply for them when they no longer extend their goodwill? Can you feel connected with all of mankind even in the Unknown, when love has yet to be nurtured? Can you let go of the outside world? What is the world of your creation? Are you safe and happy in the environment that you have created for yourself? Do you feel contentment in your social life? Are you happy with the way you are in your world?

Self-Effacing Rhythm of Life

Sincere words are not elegant,
Elegant words are not sincere.
The Wise do not need to prove their point.
Those who need to prove their point are not wise.
The Wise are not full of facts.
Those who are full of facts are not wise.
The Wise do not hoard.
The more the Wise live for others,
The fuller the life.
The more the Wise give to others,
The more abounds.
The Way of the Tao
Benefits, not harms.
The Way of Heaven
Is through service, not striving.

If you are called to serve, are you open to the call and its meaning?
Are you accepting of the self-effacing rhythm of your life? How do
you assist others? How is your service received? Are you honoring
yourself by assuming these responsibilities? When giving, how is
your life enhanced? What does being in service teach you? Can you
honestly fulfill your obligations from a place of love? As a woman, can
you detach yourself from the worth of others and create relationships
that empower each other to share and live in a joy which respects the
heart?

*Have you the courage to love with the
wisdom and power of your soul?*

Epilogue

I hope you have found, as I did, inspirational treasures from *The Tao Te Ching* offering truths that reveal the way of your being. By reflecting upon these verses again and again, you can strengthen your self-knowledge in the process of self-remembrance. While self-acceptance helps you to appreciate who you are, self-accountability is the key that unlocks the potential for the emergence of your own light.

The Feminine Light is the illumination of your own spirit. The energy and commitment you invest in transforming your darkness into light, in nurturing relationships, in healing wounds, and in embracing the world is the very essence of your feminine being.

Each day, may you discover the Lotus of your spirit, bring forth your beauty to nourish and care for yourself, realize yourself with integrity, share the blessings of your own enlightenment and guide yourself gently in loving with the wisdom of your heart.

As you are guided,

Stephany Lane Yarbrough